READINGS:

JOHN AT PATMOS
and
A BOOK OF HOURS

CATHERINE de VINCK

READINGS

JOHN AT PATMOS

AND

A BOOK OF HOURS

ALLELUIA PRESS

By the same author:

— A TIME TO GATHER, Alleluia Press, 1967 and 1974
— IKON, Alleluia Press, 1972 and 1974
— A LITURGY, Cross-Currents, 1973 and 1977
— A PASSION PLAY, Alleluia Press, 1975
— A BOOK OF UNCOMMON PRAYERS,
 Alleluia Press, 1977 and 1978

ISBN 0-911726-32-2 cloth—ISBN 0-911726-33-0 paperback

Library of Congress Catalog Card No. 78-55341
Designed and published by ALLELUIA PRESS
 Box 103, Allendale, N.J. 07401
 and Combermere, Ont., Canada, KOJ ILO

PRINTED AND BOUND IN THE UNITED STATES OF AMERICA.

CATHERINE de VINCK

JOHN AT PATMOS

TO MY SON JOSE

"*All things were made by the Word. In the beginning, there was neither mind nor matter. In the beginning was the Word. St. John was properly the first Christian theologian because he was overwhelmed by the spokenness of all meaningful happening.*"

(ROSENSTOCK-HUESSY, *The Christian Future*)

INDEX OF FIRST LINES

And to Patmos I came ... 1

Nothing moves in the void ... 4

Reality is not ... 6

I speak ... 8

I am old ... 10

You have seen the world ... 12

Words began to fly early ... 15

Someone pumps brass notes ... 17

One look at the world ... 18

Blank is the page ... 20

Animal blood stains my hand ... 22

Books are opened ... 23

There is a Word ... 25

By dark-sliding waters, I watched ... 27

Something plays ... 28

I am weary, wish to be silent ... 30

Bitter, bitter this place ... 32

Script on the paper ... 34

Watch ... 36

JOHN AT PATMOS

AND to Patmos I came
 a place, ten miles by five
 of imagined isle on which to hear
 what shall be spoken.
Omens do not fall sizzling
on my plate: I must dig them up
like roots, scrape them clean
cook them in the proper pot.

The mind boils and bubbles.
Up from the sea, the sun hits
the skull, like an enormous rock.

I must be open
 the ring of my soul broken
 the seal of my being broken
 the body raked fine, a beach
 on which no one will stand.
Then a Word will be spoken
 —Patmos is the place, the spirit-space
 the meeting ground: here is where I begin.

✓ ✓ ✓

I was not listening
 could not be listening all the time:
the ear tires of the gull's cry
 of the wind rubbing against the trees.
I was not waiting: how long can you sit
 cross-legged under a Greek sun?
But I heard, closer than heartbeat
 a voice saying, "Child!"

1

Childhood is a distant station
lost in the mist of another land
but I could say yes, I am a child
alone on this isle, hearing full well
on Patmos the imaginary, the real call
louder than the waves, closer than heartbeat:
and here is where I begin.

 ✔ ✔ ✔

I live in the wilderness. Around me
volutes of the shell, mouth of the cave
curve of the sea: soft shapes
I enter deep. I inhabit the house
of the conch, pass through
coral doors, wed the sea.

The voice cries, "Child, child!"
and I am at ease, I love what I find
the salt and the sweet of what I see:
the coupling of man and woman
 she of the wide thighs
 she of the birthing spasm
 she of the suckling babe.
The voice finds me, repeats, "Child!"
and I know I am the child born of Eve
 I am heir to a vanished garden.
I look on and on. The blood in my veins
telegraphs messages, taps codes
I decipher and understand. I see the face
of my first father, dark against foreign hills:
old Adam eating raw flesh
with great squared teeth.
The ancient mother combs her hair
with twigs, sits drowsily
by the grinding tools.
She is tired, cold: fire, uninvented
lies dormant in the heart of stones.

I weep over her: my tears freeze
fall in crystal drops. The ice-age girds
the world with silver chains, drives away
the paradise beasts. The herd moves on
tearing bark from the trees
browsing for lichen in sheltered places.
I sleep in a fur-bed, deep in time.
Dreaming of bisons and snakes
I move closer to the belly of my mother.

꜀ ꜀ ꜀

The world is very small, a mudball
wet in the shaping hand. The tribe explores
draws ridges and paths, ornaments the clay.
The women, daughters of poetry, gather
feathers and seeds
thread them on leather strips.
Meanwhile, the hunters invent sacred songs.
In their brains, a twist of consciousness
a new knowing. The web is started:
cat's cradle of intricate loops
that connect story to story, time to time.
I swing in it, dangle over the road
leading into the next age and the next
passing through Egypt and Persia
moving north. The voice calls before me.
No question, no answer: only the word
 "CHILD!"
cast out like bait. I snap at it
hold fast: an irresistible power
 reels me in.

> *"Behold, he is coming with the clouds!*
> *Every eye shall see him!"* (Rev. 1:7)

NOTHING moves in the void
no eye burns in the socket of space
no voice speaks.
 —Patmos is an island-boat, an ark
floating on cloudy waters.
All time long, I heard the waves
unrolling their ancient scrolls.
I am sea-sick, night-sick and lonely;
stars have drowned, fire sleeps
in beeswax and flint.
Yet, it is happening: in the East
—will anyone believe—
a body of light slowly rises.
Wake, brothers, sisters
uncover your faces, take
to the fox dance, the dolphin leap
the flight of the geese; stand, dancing
in the coming sun! Yes, I have seen:
here, where the mud will freeze into rock
through a million years of change
the Word is stamped down, stamped clear.
And this is the first message
 —morning news sent
before mud-rims become
lips of rocks:
God is light
a diamond point cutting
through darkness, writing without pause
inventing marvelous creatures, man and beast.
Are you listening?
 No, you are distracted
by the noisy branching of time
by the years soft-falling on the ground

exposing rotten flesh, blackened seed.
Like a dog with a bone
you hold death in your jaws
shaking it with growls of anger.
How long will you bark the same questions:
"Can we travel farther? Is there a path
out and around the skull-plate
beyond the last image
lastly printed on the brain?"
　STOP!
　　Stop that pig-snouting in the dark!
Understand the way of the child
how it bursts through the birth-ring
takes the world in, easy as air.
Understand the lifting of the latch
　　the turning of the lock
　　the pushing open, the breaking through!
O Brothers, O Sisters
　　go dancing into the light
　　go, new and naked, into God!

*"I turned and saw seven golden lampstands and sur-
rounded by them a figure like a Son of Man."*

(Rev. 1:12)

REALITY is not
in the eye of the beholder.
The tree lives deep, feeds
on its own fact; it rises
trunk, branches, crown
defining itself, cell by cell
leaf by leaf. I touch, feel
green life under my finger.
If I turn, the tree neither retracts
its roots, nor rolls up its leaves.
It goes on sucking the rain
pumping sap into every twig.
Yet, something is shared:
that marvelous green machine
does not stand alone, apart from my being.
Look at the world: a network
of interlocking pieces—bird in the nest
chick in the egg, pit in the plum.
Inside the earth, the white light
of crystals, the gold flecks.
Inside the stone, patterns of other ages
scripts of ferns a million years old.
I am here, at the end of summer
standing under a ripening tree.
But it is not all: there is more
more truth than the eye can meet.
When I sleep, another day begins:
elsewhere, a heron wakes among Chinese reeds.
I accept the sun, the moon, believe
in their distant traveling.
But the truth of the matter
is not entirely seen: other spaces

beckon, places one enters now and then
darkly and in darkest night, to see
a brightness, a shining as of snow
in the midst of seven golden lamps.

"These are the words of the First and the Last, who was dead and came to life again." (Rev. 2:10)

I speak.
 Power was given
 to form sounds, to name.
I have invented so many words
 bags and pouches
in which I stuff a world
 of images and scents.

"Cat," I say.
 Called, it runs
 to the milk poured in the dish.

"Tree," I say.
 It nods in the wind
 a wild, untamed thing;
 it lives outside its name
 ignoring the words I fit
 to bark, root and twig.
The sky fills with noises:
 flapping wings
 shrieking voices.
I must break through
 push, through the blue shell
 a fistful of prayers.

"Lord," I say.
 Time cracks open
 history lies flat, a map
 seen all at once:
 rivers and roads running
 in the same direction;
 people marching on and on
 passing through arc upon arc
 of life, death, rebirth.

"Lord," I say.
 I am plucked out
 lifted into soundless space.
 The tongue tries further speech;
 the mind furiously looks
 for clipped bits of phrases
 but words are shot down
 pierced by pellets of light.
What was it that I sought?
A pure language, a way
of speaking the truth
nothing but the truth.

Now silence is held to my lips
a hot coal, a perfect answer.

*"Your strength, I know, is small, yet you have observed
my commands and have not disowned my name."*
(Rev. 3:8)

I am old
a man having eaten his years
grain by slow grain, holding
the last one, hard between the teeth:
a kernel of no taste.
Prophecies? What words can spell
an old man's visions?
What food will calm the pangs
of his eternal hunger? Not fish soup!
Not a watery slop of common things!
I want the meat
of great mythical beasts:
let them come from the north
where they live hidden
under the snows of tribal memory;
let them shake their bearded masks;
let them grunt and buck their horns!
I will hear what they say
I will listen.

The sky is clear, empty;
the sea wears, green and silky
a ruffled gown.
What do I know?
Every pebble is a world of enigmas
every salt-crystal a city
with barred gates. I seek elsewhere
I stand by another door
begging entry, knocking.
I use eyes sharp as instruments
words shaped like hammers.
I beat upon the door of air
until my knuckles bleed

until my words crack
into bloody splinters.
Shall I die in ignorance, never to see
further than the outline
drawn in chalk:
shape of a dead man's fall?

God, look at my arms
at their bony branching;
look at my heart
that dry, leathery pouch!
Feed me, fill me again
with buzzing summer sounds.
I am your child
your fading image printed
on worn and tearing cloth.
Open to me!

"I saw an open door in heaven; and the voice that sounded like a trumpet said, 'Come up here, and I will show you what must happen after this.' At once, the Spirit took control over me. There in heaven was a throne with someone sitting on it. His face gleamed like such precious stones as jasper and cornelian; all around the throne there was a rainbow the color of emerald." (Rev. 4:1-3)

> *"Do not weep, for the Lion from the tribe of Judah, the*
> *Scion of David, has won the right to open the scroll and*
> *break its seven seals."* (Rev. 5:5)

YOU have seen the world
how it hangs in the butcher shop
bleeding on meathooks.
You have seen the trembling lamb
tied in the courtyard.
 —it was your neck in the noose
 it was your turn!

The rains came first
—forty days and forty nights—
unrolling from the sky
their dark webbing.
The rivers became sinewy beasts
enormous serpents coiled
around the land. They swallowed
farms and fields, thrashed about
on high ground. Words
could no longer be spoken:
they trickled like spit
from the lips of the dying.
There were no more voices
to tell who were these people:
men, women, children drifting by
forever sunk in water-sleep.
Centuries passed, and soon enough
it was Egypt, exile, toil;
mud packed in baskets
shouldered by slaves;
the harps mute in the willow trees.
How long before the signs lead us
to another age, another place?

Through countless turns of the earth
turns of speech, twists of road
the mind expanded to contain
the data of new skills
the names of things
experienced and remembered.

You are bound to ask, "How come?
Why are we back in the cave
haunted by the same ghosts:
ogres and elves casting on the walls
their grotesque shadows;
giant goat-herders barring the door
 and we the goats on a short rope
 waiting?"

You have seen the world slashed
drained of blood.
You have not seen enough
you have not looked:
there is a child born
in the strawbed of time;
there is a word born of God
in the human speech. It spells
freedom, abundance, peace.
Between our sobs and cries
you can hear the surging song
—the gravediggers, the pallbearers
stop in their tracks; death's grin
slips away from the mask.
It is over, it is all over:
the reign of the carrion
the vulture's feast, the rack
on which the world hangs bleeding!

The child speaks of innocence saved
of life grafted on lifeless limbs.

"What proof?" you ask. None
there is none to offer, none to need.
The future calls
and it is a child that beckons
that opens the way.

"There was silence in heaven." (Rev. 8:1)

WORDS began to fly early
their wings black
each feather an iron shaft
shot through the morning sun.
They entered the city, roosted
on chimney and bedpost
perched in cathedral and shop
sounding themselves into lectures
seminars, arguments and spats.
People walked the streets
dressed in skin and cloak
printed with all manners of names.
Words mated, multiplied, infested
every house, every room.
Some were killed by hunters
guardians of the city halls;
others collapsed, were caught
eaten innocently to fatten
further speech. They cried out
they shouted, they fell into whispers
to soar again, to bring forth
new generations of noises.
They entered drainpipes and arteries
clogged sewers and tear-ducts.
They were so enormously many
the city swelled, burst forth
in a great black scream.

I send you one Word
and it spells silence, nakedness.
It says, "Peel the stifling layers
push away the choking weights.
Go to quiet, hidden places

where you can hear the earth moved
by worm and mole, lifted
by the green muscles of new plants.
Gather the silence around you:
a downy cloth hanging loose
hardly touching the bruised flesh.
Enter silence, stretch yourself
through it, leap free!"

*"The first angel blew his trumpet. Hail and fire, mixed
with blood, came pouring down on earth."* (Rev. 8:7)

SOMEONE pumps brass notes
like bullets in the air.
Hey, you sniper on the high roof
can't you see what you are doing?
Can't you be careful of the children
jumping rope in the streets? They leap
from age to age, counting rhymes
their bodies wedged into the future
pressed against the tide. They are
half between earth and sky.
Let them be! And the sleeping lovers
in the billows of sheets: they sail
through the gulfs and around the capes
their bed a raft of precious wood.
Let them be! Let the curtain fall smooth
around the window frame, let hands move
to touch, lips to kiss and speak.
Nothing much is going on:
just the ordinary business
of living here and now.
Give it time! The race toils
pushing itself up, one step
then another, over millions of years.
So take your trumpet
Angel, and come another day!

"Then I looked, and I heard an eagle that was flying high in the air say in a loud voice, 'Oh, horror, horror!' How horrible it will be for all who live on earth when the sound comes from the trumpets!" (Rev. 8:13)

ONE look at the world
and I am gripped
by a dark, devouring thing:
beak and claw tear me open;
I scream in the shuffle of iron wings.
A huge totem-beast eats my lungs
dips for the heart through bloody pools.
In its eye, the glimmer of weapons
the glint of breastplates and spurs.
Its breath is fire, a burning torch
high-blown by the wind. It speaks;
I see pale horses, pale riders
moving through its words:
"Horror, horror, horror," it says
sputtering sulphur and smoke.

Little children, beware of idols!

Stars drop, clanging like tin plates;
the moon stained with women's blood
rolls along the slant of time.
Warring tribes stream
through mountain passes, pour
over the continents—helmets
and spear-heads the only light.
The beast pulls the thread
dangling in the void: history unravels.
It is dangerous to be human:
the rifled tree lives on
the rabbit hides underground

rocks continue the eternity of stones
—but the children of man die
mangled by the monstrous beast.

Little children, beware of idols!

*"Now is the time to reward your servants the prophets,
your dedicated people, and all who honor your name,
both great and small."* (Rev. 11:18)

BLANK is the page
upon which I begin to write
the date, the day, the facts.
Word after word, I hold on
to the pen as time pulls
is pulling me away
further from this place
from this task.

But I have eyes
eyes by the thousand:
How they weep, how they glitter
in their caves of flesh!
How they flash, these jewels
these liquid wounds!
How they open
toward the future
toward the past!

Seeing, I speak
dare say these real things
over which time has no power.

When the world appears soundless
—by its choice, a clap of dream
in a bell of air—listen
for the voices
small hushed voices:
the singers hidden, unseen.
Listen to the heartbeats:
Life tapping a tune
coursing through the ages

from woman to man
from man to woman.
Even when the lights go out
 —lamps, candles and stars—
even in darkness, they speak
 they speak together:
wonder, revelation, delight.
Listen! Even the pebbles sing
 repeat in small stone voices
the holy name of God.

*"Happy are those who are invited to the wedding-supper
of the Lamb!"* (Rev. 19:9)

ANIMAL blood stains my hand
the guts of a great celestial bird
soft-spill on the sand. I must eat.
The crabs hide, the sea foams
with a milk too bitter to suck.
I take to the hunt, spear
feathered images, roast them
on the spit of my need.
I eat through the world's flesh
tear it without apologies.
I am Everyman Adam sent from the garden
sent starving to this foreign beach.
So, I feed when I must, take it all in:
earth, sky, what flies and runs.
Filled, half-settled in sleep
I am still hollowed out
I am still enormously empty.
Somewhere, there is food
more potent than meat.
I do not turn to the past
follow the snake-root of being
for you are here, Lord:
I have seen you lift the dead
out of their shrouds, return sap
to the withered tree.
Bless my hunger, Lord:
 feed me!

JOHN AT PATMOS

*"And now I saw heaven open and a white horse appear;
its rider was called Faithful and True. . . . He is known
by the name Word of God. . . . On his cloak and on his
thigh there was a name written, the King of kings and
Lord of lords."* (Rev. 19:11, 14, 16)

BOOKS are opened
 morning books printed
 with the names of ancestors
 with the world spelled out
 as a throne room
 built for a race of kings.

Books are opened
 evening books where the moon
 is a great mineral word
 a polished stone hung
 on the breast of space.
 —Night books where children sleep
 cradled in dreams; they slip
 through the rings of images
 through the pattern's chains
 to free their eyes, their hands
 to see, to touch
 beyond the written pages
 their real face, their true form.

Who speaks?
 In the distance
 chanting voices
 intone the story of a Man
 master of impossible crafts:
 his feet steady on the water
 his hands bleeding fire
 over the ground, his life
 a key forever pressed
 into death's lock.

Books are opened by the thousand
 each one a century, a moment
 through which he rides
 at an even clip. Hear
 the horse's hoofs clattering
 on the iron road of time!
 He speaks distinct words
 each one a flaming arrow
 flying straight, hitting home.
 He is here and there
 at once everywhere
 deep into the past
 high into the future, a Man
 with the eyes of his mother's tribe
 seeing once, seeing all
 in a single glance.
 He rides to the center of the target
 straight to the heart.
 His name is King of kings
 Lord of lords.

"He was called the Word of God and the armies of heaven
followed on white horses, clothed in fine linen, clean and
shining." (Rev. 19:14)

THERE is a Word
 one letter, one sound
 loud spoken in time.
There is a Word
 one green bright note
 rolling into space
 pressing atoms together
 to form seed and spore and sperm
 to burst into kingdoms of plants
 and kingdoms of flesh.
There is a Word
 one sound held and sustained
 through ages of ice and iron
 —perfectly tuned, conceived
 eternally as a perfect pitch
 of what it is to BE.
There is one Word
 radiating snow-flakes and roses
 activating generations of whales
 slipping bird into bush
 fish into sea, man into woman.
Listen! The cosmos is chamber and shell
 in which the Word leaps
 dancing a dance of creation:
 every movement a moment in time
 a profusion of years
 piled up, decomposing, giving birth
 to a new processional of days.
Listen! The music of that one note builds
 body-sequences, marvelous machines
 full-pulsing, shaping whole sentences
 saying life, life, as the blood beats.

There is one Word:
 net-full of stars, cloth patterned
 with sea-and-land-scapes
 cloak of flesh
 around shoulder of bones.
Praise God!

"There shall be an end to death, and to mourning and
crying and pain." (Rev. 21:4)

BY dark-sliding waters, I watched;
they came to mind, descending
from the hilltops:
tourists of the planet
ready to rearrange the objects of the day.
To be is not a question:
they are, in vertigo and pain
holding on to things—fingers curled
around handles, gripping shovel, frying pan, axe.
No patience here, no sure virtue:
fury spills the pot, anguish
bites the heart, fear
madly barks at the shadows.
But this is it: our world.
Glued together scale by shining scale
the sun, that great luminous fish
swims in the morning sky.
Children are born while the compass needle
trembles, marking space; while the clock
works its pattern, stamps its numbers
upon the wall.
Can a man believe, can a woman know?
The frenzied, the blind, the limping
snake through the streets
coughing blood, hiding their sores
under layers of rags. I live in Patmos
dine on the syntax of the dazzling isle
while elsewhere children feast
on potato peels and rats.
Can I believe? The question
is a hook piercing my tongue.
I bleed, but say YES!

"Behold, I am making all things new!" (Rev. 21:5)

SOMETHING plays
 between the lines
something bright
 never stops flowing
 in and out of dark landscapes:
 threads of light spun
 from a golden fleece
 twisted together, played
 against a darker theme.

Blood crusts the sheets
 stains open, mortal thighs.
The newborn child sucks in
the world's bitter taste
 screams
as time rolls downhill
 faster and faster
a rough stone scraping
 scarring the skin.

Something plays, dances
 between the lines
 a robust spirit
 a fertile power pressing
 swollen seeds from dying bloom
 newborn babe
 from ancient human ways.
Blessed are those who believe!
They see life's thread pulled
 bright and silky
through the needle of death.
Their bones mend;
now and then, they see

—more than connections, correlations—
the whole dazzling pattern
the full script.

They live, live forever!

> *"The city had no need of sun or moon to shine upon it:*
> *for the glory of God gave it light, and its lamp was the*
> *Lamb."*
> (Rev. 21:23)

I am weary, wish to be silent
to burn the fat of words
to let them sizzle in the fire.
Will they give light
when the night comes in
with tar and feathers
to glue the world still?

I eat, I spit, I am sick
of the taste of speech.
I wish for silence:
to be ushered in a space
where nothing is heard
but air displaced
by infinite resonances
echoes thinned out
to soundless vibrations
saying peace, peace without end!

I bear the sign
of the Man who steps free
out of the sealing stone.
Behind him, the wrap of time
the worn skin of the past.
His finger stirs the sand
lifts dazzling atoms:
worlds of white light are born.

I want his steady touch
I want to stay with a knowledge
longer than time.

But over and again
I pass through the door
visit the great house of language
find bones, amulets
find mostly the word "pain"
a spike pushed through the flesh
within the bleeding wrist.

Somewhere between earth and heaven
there is a rising
a solar shine, a being
gold and fleshed
for which no name was ever found.
I see, I cannot speak.

There is silence
 through which the Light thunders!

*"Then he showed me the river of the water of life, spark-
ling like crystal, flowing from the throne of God and of
the Lamb down the middle of the city's street."*

(Rev. 22:1)

BITTER, bitter this place
scrap of land, raft
anchored among the waves.
Bitter, watered by tears
the words I write to take
the measure of the wind
the speed of images passing
with clouds, with time.

I am alone
 I am not alone:
in these immense fields
millions upon millions float
in primeval ooze, ready to be born.
Death, as a midwife, stands by
a nurse, gentle of hands.
And what am I among these people:
a speck lifted by brooms of air
a flake melting in the heat?
The dust rises, the sun falls
on the shoulders, heavy
like a yoke of brass.

I prayed the Lord, held his name
hot and glowing in my soul
and I saw
 not with the eyes of a stranger
 but of a son coming home in the evening
 by paths of guiding stars.
I heard my name called
out of time, in a tongue
I perfectly understand.

Dark, it is said, dark is God's dwelling
but I saw it clear
saw it with naked eye
a space without volume
without length or height
—nothing about it in any book—
and I lay still and glad
a little sparrow
in the feather-nest of God.

What name, what word, what sound
can match that pure feeling?
I could say there was a city
carved from a single crystal
—the light within neither fire nor lamp—
but it would be a second print
of a first truth, a shadow
of what is shadowless.

I am alone, rooted on this shore
and the waters crackle
and the sun spreads its red ink
floats like a jelly-fish
on the surface of the sea.
There is no door at which to knock
no stone to turn, no house to enter.
My eyes are opened, my old eyes
brimful of old images, painted
by many years of knowing the truth
in a certain human way.
I keep watch, I pray:
"Lord of this small planet
and of, smaller, this estate
of ivory and skin
 remember me in your kingdom!"

"The Spirit and the Bride say, 'Come!' " (Rev. 22:17)

SCRIPT on the paper
words rounded like ant eggs
white and fat
 saying what?

It is the end of time:
darkness clicks shut
a giant lid tightly fitted
over the rim of space.
Once, there was a city
glittering with the fire of women
with the light of their breasts.
Once, there were children in the womb
alive, delicately curled
like ferns in early spring.
Once, there were people
knowing the right use
of iron and salt—makers of tools
builders of temples.

Now, there are fragments of flesh
sticking to bark and stone.
All the postcards have been sent:
Goodbye! Bon voyage! Adieu!
Brother, sister, father, mother
they are droplets in the air
shadow-prints upon exploded walls.
The tiger, the elk, the bear:
their ancient images are locked
in charred books. The reign
of the cockroach begins.

There will be a new earth
 and a new heaven:

the Spirit and the Bride say
"Come!"

They will be ready
they will come
 out of broken picture-frames
 out of albums, letters, yellowed telegrams
 —Get well! Rise and shine! Soon
 very soon—
 out of burial mounds
 out of the drowning sea
 and the sucking swamps:
 mothers with children in their arms
 lovers entwined
 all going to light, speaking
 good words related to real things.
It is not, hazy and slow-winding
a dream from which to wake
sorry and sad:
it is the truth, the whole truth
summed up in one Word eternally spoken
 —and all life lives on
 in its sound.

*"Come forward, you who are thirsty; accept the water of
life, a free gift to all who desire it."* (Rev. 22:17)

WATCH
 when there is no sound
 for the sound of cloth tearing
 smooth and long: a shroud
 being rent from within.
Something free is being born!

If you look
 through the dull shine of time
 through the glass misted over
 by centuries of rain
you will know: this Man is gone
who was carried deep into the rock.
He is walking in the blue morning
 cracking death, that word of stone
 between the wheels of his hands.
He walks masterless in a world
where people move by bullwhip
 —the fine tip barely touching the skin
 but the threat real and pressing.

He sees the trembling faces
 fragile crystal faces:
 they break so soon, fall
 into a thousand frozen pieces
 —here an eye forever fixed
 there a mouth forever trapped
 voiceless under the ice.

Take the bread, he says
eat yourself full of life
 —strong the light over the world—

Take this whole marvelous sun of bread
this whole full circle ever circling
container of planets and stars
earth and heaven. Eat!
And drink deep, beloved
drink to sleep and to waking
in the blue morning
where I walk
masterless, free.
Come with me!

what do we show
 but contractions of fingers
 over knobs of sleep?

Lord
 open the shutters of time
 the gateway of speech.
When we leave the night's cave
shall we remember the dream-house
 dream-city through which we passed
 counting birthdays, counting death
 by fire, flood, tormented wishing?
What was handed to us
 through dark vaporous doors?
What password, skill, sign
 from what outreaching past?

Lord
 see these cold words change
 from deep to pale color
 as the future begins to shine
 in brilliant prophecies:
a power, bright and blowing
 shakes the crown of flowering trees;
stars leave us, the moon turns away
 to lift other seas.

Lord
 we come
 into the dailiness
 of bread, room, street.

Bless us
 as the bird of dawn sends
 to our waking brain
 a first needle of sound.

PRIME

FROM the turned page
 in the book of creation
words fatten into substantial forms:
let there be light!
And light comes to the hand
 the aluminum roof, the milk
 in the glass pitcher on the table.
In the tree
 green with life before time
 the bird of the first stanza
 begins to sing:
 music shapes the world
 feathers house the new day.
Structured bodies in structured rooms:
 bone answers beam
 eye measures the distance.
Shall we walk on the penciled line
 holding what we own
 in precise equilibrium
or shall each moment be invention
 a fleshing act:
 words over the spine of thoughts
 skin over rushing blood
 color coating common facts
 violet for sorrow
 red for love?
On the huge canvas
 the aurora becomes an imperative
 a power forcing out of earth and wood
 a world of resonance, an art
 hatched whole and living.
Water washes over us
 a loose, flickering thing

rising from sacred deep caves
to enfold, to cling, to fit us
skin-tight in silver chill.

We live by association
 by the curve and turn of images:
Where has it dripped away
 the time when good-morning held
 the roundness of a child waking
 to oatmeal and sea-sounds
 —water-bells of the waves
 gong in the heart of the shell?
The lost garden is a pin point on the map:
 where are the flamingos and the peacocks
 hand-fed tigers and monkeys?
Eve, that odd, unremembering woman
 comes to the breakfast table
 offering
 with coffee
 an apple half-eaten.

Lord
 the summer crackles underfoot.
 The winter to follow
 will be stone, hard against the knuckles.

Lord
 does the subway mouth lead
 to your underground
 to the gold vein of your love
 the sapphire of your speech?
 Or shall it bring us dead-center
 in the wrong of hellish pain
 —throat slit, pockets picked clean of hope?

Lord
 bless this day
 for you, beyond counting;

for us, a small uncertain measure
a spoon dipped in a protean sea.
Yet, how can this be
that we are mad with the thrill
of seeing the sun lit:
fire restored
lamp set high, set firmly in the mind
revealing durations, epochs
all ages and norms of man?
Seeing is believing:
Lord, we know!

LAUDS

FORTY days and forty nights
 through the desert:
we walk from past to future
 shedding the fleece of old
 leaving the meat stewing
 in the clay pots of Egypt;
 moving where
 —quails in the wind
 corn-flakes in the morning—
 where the opening sea
 the cloud
 the fire-pillar
 show the way.
Daylight falls still in the room
 where bed, chair, glass
 the rose bleeding on the table
 settle in solid utterances.
We enter the fold of garments
 the hollowness of sleeves
adjust over eye and mouth
 the pigments of the ceremonial mask.
Groomed and shod, we are ready
 to pass through an imagined door
 to enter a new world.

Something moves through the cloud
 a voice moves alive
 moves life into flesh
 into man, woman
 into the sparrow's throat
 and the seed's core.
Shall we drive on
 past these rocks shaped

by fingers of sand
or choose a single stone, altar
to offer aromatic wood, a handful of fire?
We come
with disconnected words:
"Light"
we say;
"Lord"
we say
offering the crackling manna
pouring the milk of dreams
into the breakfast bowl.
The desert has sifted its crystals
into our blood: we carry these particles
—silence, solitude, wild wishing—
in the ache of our soul.

Lord
in the country of the morning
we row the sandy rivers
choking on dust and smoke.
The walls
—of animal skins
stretched on crossed poles—
can be folded, carried
a thousand miles against the wind.
Memories glimmer
jingle like coins
in our pocket.
We breathe time
in and out
stretch our arms
like branches to the sun.

Lord
yes, we praise thee!

TERCE

DARK-hearted with seeds
sunflowers line the garden path.
Yes, we have seen the pleasant house:
pears on the windowsill
coffee on the table
books, green plants, a new fire
growing under bundled twigs.

Lord
can we break the crust of this day
can we lift the cup, drink this hour
before it turns brackish and brown
seeps away through the cracking glaze?
Over and over, we twined
one moment to the next
our hands steady
trying for a pattern never held before.
Twisted in the love-knot of your making
hidden in the form of your secret
we are
Lord
naked only in your sight.
Through all these rooms
—small and smoked
mere chinks in the face of the rock—
we move bone to bone
breast to breast
dressed in each other's speech
in the silk of our mutual giving.

Lord
we have thieved:
in the ancient distance
apple of succulence

first knowing of misuse
of disconnection
sweet morning fruit
golden intelligence flashing
the fortune of its thoughts:
(*"Our* knowledge," we say
adding another coin
to the careless heap.)

Behind us:
glitter, mortality, pain!
Before us:
glitter, mortality, pain!
Yet, so many years in the finding
this one clear space
this place where planets and pebbles
animals, flowers, men
mesh in the convergence of your sight!

We speak
we are spoken.
We call
we are called
and the voice never fails
but increases
changes from one intensity to another
forming new sounds:
"O"
of wonder, of openness
gold disk, ornament of winter
gate to let in
O your Sun!

SEXT

EARTH eroded, stones shifting
tigers nearly extinct
 and time?
Time waterfalls away from us.
In the melting noon
 all things drop
 ripe and open
 fruits of the half-way
 to be eaten on the road
 before the whistle blows.
Where are we?
 Is the day a coil around us
 a locking circle?
Or is it set deep in an ancient wall
a window looking out
 towards pastures
 beribboned children
 legions of angels?

O world of common sight
 of sweat and cry, argument and tension
 penumbra that calls light:
here we are
 home in the green shade of the maple
 patterning the dust with our weight
 pecking with the sparrows
 the crumbs of the past.
We came from buried cities
 from the pits where bones are gathered
 wing-bones, antlers, tail-rings and tusks;
we came from the formlessness of water
 from the curve and twist of millennia
 the bending of the bow, the arrow flying. . . .

We came together, many-voiced
and the stories we tell
 recounted from age to age
hang in the air like scrolls
 unrolling in waves of color:
smoke-blue for all the cooled worlds
 of men and beasts and plants;
black for the tears we shed
 through a thousand and one nights;
green for the grass-nests
 where lovers in each others arms
 summon the future.

Lord
 the stones of morning
 —clean-washed stoops over which
 so eagerly we tread—
 gradually darken; our shadows
 fall limp at our feet;
 we pull them
 —shadow-bodies
 shadow-worlds.
 With every step
 we haul their leaded weight.

Lord
 hidden in ourselves
 hunger screams
 thirst rakes the chalky riverbeds
 of rainless countries.
Let us find the swollen hive
 the honey-well of meaning.
We seek beyond scrawls and garbled words
 beyond the sign engraved
 on the face of the rock
the secret of the light we cut and cross:
secret of man ascending the ladder of being

through what ruptured link
holding what guiding thread?

Huddled against the earth's brown skin
we hear a muffled rhythm:
 beyond the proof of experience
 a remembered unknown song
 life-charged, wind-full
 lifting the smell of pitch
 from the pits
 speaking the names of dead hunters
 calling the gatherers of berries
 the pluckers of wild apples.
They come, keep coming
 in the long pause of noon
drumming words of a communal song
rubbing sticks till the flame leaps
 blue and crested
out of their distant hands
to warm the present day.

Lord
 keep us still
 as time turns on its hinges
 like a creaky door.
We cannot go on forever
 lifting the ram's horn
 to blow our screeching questions.
Hold us in soundlessness
 with mind polished
 a brass mirror in which faintly at first
 a reflection appears
 an imprint intensified
 from moment to moment
 from year to year
 till suddenly we catch
 without touch or sight

the full slant of your hidden sun.
What we see on waking
 —shape, place, the stand
 of habitual trees—
retains its literal form:

September stains the woods: ferns are yellowing, and on the slope where stones have marvelous dark eggplant skins, water runs cooler, slips a silver chill through the grass. In the blurring haze, the house looks brown-feathered, an old hen brooding in a weedy yard. We are fingers, hands, legs at work in fast-moving traffic—clouds in the sky, cars on the road, rotating planets. We are silk knots of nerves set within delicate organic shells; we are ash and limestone. Hello, goodbye! We grope through rarefied air along tracks of vibrant energy. All of it, the allness of all kingdoms, the juice of the universe, nectar of unknown stars, of barely perceptible cells, flow into a cup hollowed out of clay, sky and stone. We press it to our lips, O Lord of the Meridian, and drink.

NONE

TIREDNESS sets in the bone
 deep like an axe.
We have not seen the land
 promised to our tribe;
we roamed the wilderness
 leaving neither script nor track
 carrying our life, its weight
 of leather and rag
 through time's rippling waves.

Home
 is a million miles away
and what we hear, the news
 of distant battles, the cries
 of burning children
roars in our brain:
 small ghosts of supplication
 they beg through enormous spaces
 for soothing oil, a bandage
 a cup of oblivion.
It is not flesh that fills
 suit or dress or glove
but an infinite number of grains:
 sand-man sand-woman
 we stand
blind and still
while the wind moves the world
transporting huge chunks of land
 whole cities, centuries and ages
from one dark place to another.

Smell, sight, touch:
 we long

for the brew in Egypt's pots,
 herbs, onions, lamb
the pause by the campfire
the idle talk of noon.
Who will come to us in this hour
 with lips of water
 liquid fingers
 river hair?

Lord
 we thirst!
There are no watering places
 on the moon, no pail or spoon
 to dip in the milk
 of that beautiful face.
We need no abstract terms
 cold knife of logic
 iron pincers of thoughts
 forged in hellfire.
We need no smear of moondust
 on insulated boots:
we need the earth's moisture
 the mothering ooze
 fertile womb on which to rest
 at ease and in pleasure.
We need the touch of others
 the clasping arms
 the joined hands.
We need beauty
 —she of the carved granite
 palace-figure with jeweled lid;
 she of music, poetry
 constellated with images
 resonant like bell-metal!
We need
 eyes to see

the other side of life:
what we wear close to the skin
 that rough and prickly cloth
 that wool spun with brambles
is not the whole garment.
At times, we finger the silk
 of a celestial cloak;
we hold handfuls of a fabric
 woven on a loom stretched
 from north to south, manned
 by the four servants of the wind.

GOD
 we need you!
Heal what we keep hidden
 under the thousand folds
 of our perpetual smiling:
the slashed heart
the mind grown slack
 soft under its shell
 and like the crab, burrowing
 to dark retreats.

Lord
 with a hand that is no hand
 but a diamond of shattering light
follow the contour of our pain
cut, deepen the wound
 till it becomes a door to your mercy.
Much is discomfort here:
 gritty sand mixed with manna
 the space for language
 crowded with careless words
 and hope narrowed to the sight
 of an undulating belly
 in the next oasis of the mind!

Lord
we have moved horizontally
all over an empty land.
Now we pause to gather the black thorn
to build a fire on the stony slab
of this hour.
We need a sign:
Shall it be other
than the buzzard's circling
more than the bloody stain
of the westering sun?
It is enough
to be
to say
Lord!

VESPERS

LONG rope uncoiled
 sleeping serpent
 no flute can charm
the hour lies dark and still.
"A thousand years is like a day," says the Lord.
Yesterday
slipping our hands
under the rock, we caught small crabs
for our supper; the place is lost:
we do nor recall the stream;
our other ancient face
curtained by millennia, recedes
 in the wrinkled water.
Time drops
 from what height
 into what endless depth?
Yesterday
 our daughters shaped the world
 to the roundness of their breasts;
today
 their breath freezes
 into snow-flowers
 white roses of cold metal.
Our sons' eyes were jewels
 embers glowing in the fiery masks.
Their dreams formed a maze
 a network in which to trap
 deer and buffalo.
Today
 they do not know the earth
 as nurse and woman.
They come home
 and life is a key in a determined slot

the turning of iron into wood
the coming into a room
where table, chair, food
are wild devouring powers.

Lord
 it was given to us to dance
 with the swelling of the buds
 the growing of the leaves;
 to invent rhythms, improvise sounds
 build a temple which would hold
 country, metropolis, planted field.
Now, we buy five stalks of wheat
 —dried, the heads drooping—
and nail them to a wall!
Who shall buy the wind?
Who shall touch the rising moon
 with rubber stamp or leather boot?
Who shall wear moon-chips
 as ornaments on neck-chains?

Lord
 what will happen
 already happens now:
 the idle fact, fattened
 by numberless numbers, multiplied
 added infinitely to the sum of itself:
 stone upon stone, bone upon bone
 dust over dust:
 death
 nothingness
 black death!

Lord
 keep the bear and the crow
 away from our flesh; deliver us
 from the lion's jaw.

In the night, they come hungering
to the bed where we lie
 folded upon ourselves
 knees up to chin
 rolling down huge mountains of sleep.
They wait among the image-trees
 dream-animals, spirit-hunters
 leaving real tracks
 inflicting real wounds.

Lord
 let us know
 even at this late hour!
The world is warm with your flesh:
water, fire, earth and air—your holy flesh
 vanquished and resurrected
 dying and ever-born
 cracking the stone open
 breaking the doors of death
 rising
 forever rising!

Lord
 this is our future:
 written in the palm's lines
 in the contour of every pebble
 in every rain-drop and cloud-shape.

We live
 not by imposed laws
 by grim deadly edicts
 but by that word which is freely spilled:
 love-seed in the sower's hand
 and the furrow wide open
 moistened by a long-ago stream.
Blessed are you
 Lord God of all creation!

Blessed are you
for the ground of our dying!
Dust shall not sift into our sealed eyes
shall not reach our flesh's ragged pockets.
By the door of our leaving
you are
setting us aswim in your saltless sea!

COMPLINES

WE read by the lamp:
 the wick slowly sucks the oil
 feeds the flame
 even as we now draw fire
 pluck the small lights of words
 from the turned page.

This time
 —open space to which we come
 surfacing with root-strength—
this time shall not be lost or found
 only transcended
 carried over and out
 of its perpetual turn.
On the other side of the wall
 —fox, beaver, otter, bear—
they call our animal spirits
 to the moon's radiant wells.
"Come," they say, "be reborn in a dream."
But continents throb around us
 centuries stand in circles
 and history is on our mind:
 the vast panorama of acts and laws
 the vision rearranged a thousand times
 by the born child, the dead man.

We have hands other than to touch
 eyes other than to see;
and the light we force
 out of oil and sticks
shines dark before the candelabra
set high on the templed stone of this hour:
seven-branched and all-knowing
 it drips hot with God's wax.

The sound, a monotone of voices
 word-pellets upon the skin of silence;
the sound pulls the snake out of its coils.
The emblems on its shield
display directions: it will lead us
if we wish, to the old quarry
 the cave velvet-hung with bats
where it will grow out of itself
and around us: an iron ring
 an absolute clasp
 from which there is no breaking.

Lord
 cut the knotted syntax of the beast
 —wars, tortures, killings
 are locked in its speech:
 daily, the world gets on
 with the deadly business!

Lord
 where are delight, revelation, wonder
 the spirit of the dance
 —man dancing in and out
 of the seriousness of events
 wearing laughter
 like an ultimate cosmology:
the twinkle of stars on his face
the sun's blinking eye shining
 clear through his pain?

Lord of lichen and bark
 of mushroom and goldenrod
crush the shell and seed of our days
mix the pigments and press them
 bleeding-wet into the shape of your praise.
Are we more than sparrows
 more than an eyelash curve and shade?

If we must sum up
 the talk and the deed
 —Lord, this is the midnight
 of our trembling—
let our naked truth fall like a stone
speed on forever in the abyss of your mercy.

It is late: the flame, for lack of oil
 now eats the wick
 feeds on our soul's tender marrow.
When shall we know
 without lense or lamp
the reality of the real?
 We are
these bodies silver and gold
overlaid by everlasting brightness.
The great pell-mell of the hive
the buzzing sound of the swarm
conceal the master-plan
 the honey mounting in the structured cell.
Time makes a curve, draws
a hazy circle around us
tells
 —but it lies—
the alphabet we spell
the script over which we labor
dissolves equally in water or fire.
Tells
 —but it is the ghost of a truth—
the house we build day by day
is of air and spidery webbing:
rain bears down on the roof
the beams rot and through the floor
the mandragora, the man-shaped root
 pushes its blind power.

When the prince of death appears
at the window, wagging a bony finger
 —Oh, the time will be ripe:
 we shall not die forever—
our hearts shall send out rays
outreaching the dark as we say

LORD
 INTO YOUR HANDS
 WE COMMEND OUR SPIRIT.

19 78

SET IN ELEVEN POINT TIMES ROMAN AND EIGHT
POINT ITALIC AND PRINTED BY THEO. GAUS, LTD.
BROOKLYN, N. Y. TWO HUNDRED AND FIFTY
COPIES BOUND IN CLOTH AND SEVEN-
TEEN HUNDRED AND FIFTY COPIES
PERFECT BOUND CONSTITUTING
THE ORIGINAL EDITION